Chris Johnson and Barbara Bullock-Wilson

WYNN
BULLOCK 55

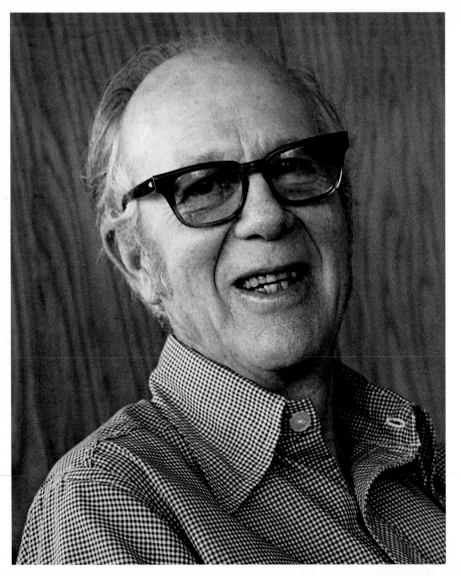

'As long as I can remember, I have been filled with a deep desire to find a means of creatively interacting with the world, of understanding more of what is within and around me. It was not until I was 40, however, that I decided photography was my best way. When I photograph, what I'm really doing is seeking answers to things.' Wynn Bullock

Wynn Bullock was fond of pointing out that it is a mistake to take anything we see for granted. He knew that insight usually hides behind what appears to be obvious, and this applies as much to his artwork as to anything else in the world. This is why Bullock spent much of his life formulating and teaching his ideas, often to the bewilderment of those who admired his photography but didn't want to be troubled by what they felt to be needlessly complex philosophical concepts. These concepts, however, were essential elements in his creative life. Bullock was at heart a philosopher who used the medium of photography as a way of engaging in and expressing his search for meaning.

Bullock lived and worked at a time when the foundations of photography as we know it were being established throughout the Western world. In Europe, Bill Brandt was producing brooding documentary photographs, stark portraits and surreal nudes that held eroticism and formalism in dynamic tension. In the United States, Dorothea Lange, Walker Evans and W. Eugene Smith were redefining documentary photography and shaping social history. In Mexico, Manuel Alvarez Bravo was creating complex symbolic photographs under the influence of sophisticated theories of the unconscious and indigenous folk culture. Great artists such as Minor White, Aaron Siskind and Imogen Cunningham were all producing their best work.

For fine-art photographers of nature, the heart of the creative world was in the mountains and along the shores of central California. There, in the 1940s and 50s, Edward Weston, Ansel Adams and Wynn Bullock were the acknowledged masters of what became known as the West Coast School of landscape and figurative photography. Of these three, Weston was the elder mentor whose masterful artwork and passionate devotion to what was then called 'straight photography' provided an influence that helped define the genre. For Weston, the inherent qualities of forms seen clearly and directly were a source of inspiration and revelation. The emphasis for him was on finding the 'strongest way of seeing' the simplest things so that they became organic sculptures in luminous and exquisite prints. Ansel Adams was a master of rendering the imposing gestures of nature. For him, nature was a source of grandeur, awe and eloquence.

Unlike Weston and Adams, Wynn Bullock came to photography somewhat late in life. Gifted with a lyric tenor voice and deep sensibilities, he first pursued a career as a concert singer. Then, in the 1930s he managed his first wife's family real estate business, successfully weathering the economic hardships of America's Great Depression. It wasn't until 1938, when he enrolled in the Los Angeles Art Center School to study photography formally, that he began thinking of it as a desirable new career. After graduation, Bullock continued to develop his art while earning his living as a commercial photographer. Before meeting Edward Weston in 1948, he devoted most of his creative energies to exploring the aesthetic and technical possibilities of solarization, photograms, reticulation and other alternative photographic processes. Although he produced a number of striking images using these techniques, he set them aside after experiencing the power of Weston's approach. Realizing he was ready for

change, Bullock found the directness of Weston's imagery, along with its infinitely subtle range of tonal values, deeply appealing. Adopting 'straight photography' for himself, he discovered a whole new way of experiencing and relating to the world that launched him into one of the most fertile periods of his artistic life.

Within no more than half a dozen years, Bullock had developed such a distinctive vision and mastery of his craft that he established himself in the minds of many as a peer to Weston and Adams. And in 1955, when two of his most significant photographs of that time were chosen by Edward Steichen for inclusion in the historic 'Family of Man' exhibition at the Museum of Modern Art in New York, he achieved worldwide recognition. There is, however, an interesting irony in the fact that these three artists are often seen as equally representative of a classic school of photography. Despite some broad formal similarities that exist in their work — all three used view cameras to photograph Californian land-scapes and both Weston and Bullock used the nude as a key theme — more is obscured than revealed by this association. Of the three, Bullock's work is by far the most haunting and reflective, evoking an interior landscape of qualities and forces rather than an outer world of literal places and things.

There are many photographers whose work clearly reflects Weston's formal elegance and Adams' richness and technical proficiency. Bullock's influence, however, is harder to trace in the generations of artists that followed him. This is in part because Bullock was committed to a profoundly intuitive process that cannot be emulated in any facile way. The truth of photographer Morrie Camhi's statement that 'We do not see things as they are. We see things as we are ... ' explains why styles of photography follow from the predilections of

makers, and Bullock occupies a unique position in this regard. Some photographers create through what can be thought of as a process of photographic discovery. They believe that meaning resides in an objective reality and, for them, art is a process of searching, finding, framing and representing what they discover in the world. Weston and many of the great documentary photographers such as Eugene Richards and Garry Winogrand exemplify this approach. Although Weston's discoveries were of nature and those of the documentary artists are social and political, they all look to the outer world for sources of inspiration. Others work through a process that the critic A.D. Coleman called 'directorial'. For them, photography is a projection of meanings onto subjects who become actors in their work. The inner, rather than the outer world is what matters, and the subjects or objects they photograph are reflections of personal realities. Judy Dater, Jo Ann Callis, Jan Saudek and Philip-Lorca di Corcia are good examples of photographers who work in this way. Still others begin with what is essentially a blank photographic canvas and fabricate, through arrangement or digital assemblage, imagery that is often surreal and fantastic.

Bullock created his work through a process that would be hard to locate in any of these general categories. What set him apart as a photographer was his passionate desire to know what was true about the essential nature of existence. As he developed his perceptual powers and as his levels of awareness expanded and deepened, he found that he also needed to develop new and different ways through which he could visually express what he experienced and discovered. He had both the curiosity and rigour of a philosopher and scientist as well as the intuition and empathy of an artist. He was profoundly moved by the insights that emerged from his explorations, and these feelings became the basis for the way in which he approached his work.

When the conceptual artist Robert Irwin said, 'Seeing is forgetting the name of the thing seen', he was describing an infinitely brief moment when our experience of something is not constrained by language. It is difficult to suspend our tendency to define what we experience. And yet it is in that moment, before definitions limit the sensual possibilities of knowing, when creativity can lead to new understandings. Referring to his work in the 1950s, Bullock talks about this phenomenon: 'My feeling of four dimensional space-time came directly from my contact with the things I photographed. When I first became a photographer, I photographed with only a conscious awareness of objects and their physical qualities, plus an academic awareness of how to compose objects within the format of my print. It never occurred to me that objects had their own real time, and that space was fullness, ranging physically from solid objects to invisible air and light. In short, I never thought too seriously of either. Only when I became dissatisfied with object seeing and photographing did I seek another way. My search led me to a greater awareness that all objects were events constantly changing on sub-microscopic, microscopic and macroscopic levels in time and space. This included everything. My entire viewpoint gradually changed as did my pictures. For myself, I needed no definition to make me aware of four dimensional space-time events; I felt them.'

Nurturing an open, intuitive, experiential approach to life and art, Bullock over and over again created new languages of imagery to symbolize his constantly evolving awareness of himself and the world around him. 'What is material, tangible and permanent to most people', he said, 'is ephemeral to me. Change is what I believe in. It is the essence of learning, growth, and creativity.' A source of inspiration and sustenance for Bullock's dynamic approach was the work of Alfred Korzybski, the Polish-American linguist who formulated what

became known as General Semantics. A key concept for Korzybski was 'the map is not the territory', or as Bullock liked to think of it, 'the word is not the thing'. When Bullock went out photographing, he strove to set aside what conventional thinking told him he was seeing and establish fresh, direct relationships with the things themselves. He understood that his pictures were symbols and that their power rested not only in how meaningfully they revealed something of the nature of what they were symbolizing but also in the relative significance of what was being symbolized. His lifelong commitment to self-development was always in the service of being able to see more clearly, feel more fully and relate more openly so that he could come ever closer to universal truths — both as a seeker and as a creator of meaning.

During much of the 1950s, Bullock's photography flowed from his experience and awareness of the four-dimensional, space-time character of the world. Throughout this period, some of his favourite places to work were the wild and untouched areas around where he lived, or areas with old deserted buildings almost returned to nature. In such environments, he said, 'the human figure, the trees, plants, ferns, and flowers manifest the cyclic forces of life and death in various characteristic stages of development. All blend into my experience ... as events. Since I experience everything as an event, I want my photographs to express events. I reject the concept that a photograph freezes things in time merely because it records them at a particular moment in time.'

For Bullock, experiencing something as a space-time event meant really seeing and appreciating its qualities, noticing its interrelationships with other events, feeling its dynamic nature. One of the most powerful ways that Bullock found to

symbolize events in a still photograph was through the development and use of the principle of opposites. Take, for example, *Nancy at Point Lobos*, 1953 (page 33). The smoothness and grace of her body are known in relation to the sharper, more discrete and varied textures of the surrounding vegetation. The light and warmth of the sun is felt because of the presence of shadows. Her distinct temporal reality – that of a young woman – is in contrast with the temporal realities of the rocks and plants, earth and sunlight surrounding her. The ease and comfort she reflects in being where she is conveys a belonging. So does the absence of clothes. She is part of the whole, yet the hint of a blanket underneath her points to a difference, a separation. She is both part of nature and apart from it, a unique and interrelated event, being and becoming with all the other events contained within the image.

As a signature element in his photography, Bullock's application of the principle of opposites accounts for much of the rich meaning that can be found in his imagery. An awareness of the principle, however, does not only enhance our appreciation of his photographs. It can also serve as a useful concept in and of itself. In this case, to borrow a term from Marshall McLuhan, the medium becomes the message. Bullock's understanding that 'opposites are one' – that you can't have up without down, hard without soft, joy without sadness – points to a more inclusive, less fearful and more flexible way of thinking and being. Thus, in addition to their intrinsic symbolism, many of his most moving images can be seen as life-affirming metaphors for goodness, hope and love.

Not surprisingly, anyone encountering Bullock quickly discovered an open and generous spirit, eager to share ideas with a warm but passionate intensity. Although he knew that people admired and valued his work, he was not in the

least awed by his celebrity within the world of photography. What was really important to him was not the recognition that he had certain experiences or insights or accomplishments, but rather how those experiences, insights and accomplishments contributed to his growth and his ability to be of benefit to others. Teaching, lecturing and writing were all exhausting activities for him, as was the practice of keeping an open house to those who sought him out. As long as he was physically able, however, he continued to give of himself in these ways because of his excitement and deep belief in both the process in which he was engaged and, through it, what he was learning. Connecting with kindred spirits and encouraging them to discover the transcendence that is possible when one makes the effort to probe beneath the surface of things was what the value of the process and the learning demanded.

During the early 1960s, Bullock turned away from black-and-white photography and produced a body of work that he termed 'color light abstractions'. As a child, he had been fascinated with light. While he was studying voice in Paris in the late 1920s, he discovered the work of the French Impressionists and post-Impressionists as well as the photography of Man Ray and László Moholy-Nagy. What these artists did with light inspired him to buy a camera and begin making photographs. It was the satisfaction he derived from his light-based hobby that eventually led him to Art Center. From that point on, his interest in light only deepened, manifesting itself as a continuing stimulus in the evolution of his vision and skill as an artist. Seen in this context, the 'color light abstractions', while quite different in appearance and technique, fit very naturally into the whole pattern of his creative work.

In making these photographs, Bullock was exploring what he believed to be the greatest living force – what he once referred to as 'perhaps the most profound truth in the universe'. Using a specially modified camera that was capable of focusing at extremely close range, and materials that transmitted, reflected and refracted light, he was able to eliminate identifiable objects and through the process of abstraction focus directly on light itself. As he worked, light became the embodiment of the energy, flow and continuity of life, and the photographic images he produced symbolize those realities in astonishingly beautiful and varied ways. The element of colour allowed him to evoke the richness and spirit of light, while the element of abstraction enabled him to go beyond the complacent 'knowing' that frequently accompanies familiarity, and come closer to the essence of its infinitely complex nature as a force within and around all things. His 'color light abstractions' offer a window through which we can glimpse the universe in process.

Having immersed himself in a cosmic world of animating forces, when Bullock returned to black-and-white photography in the mid-1960s, he found that he experienced everything around him with a deeper awareness of time. Throughout history, human beings have struggled with insistent doubts and anxieties about this phenomenon, which philosophy, psychology and spirituality have all attempted to address in different ways. The noted psychologist Otto Rank, for example, has written that our basic suffering is rooted in what amounts to a 'fear of life'. On the one hand, we grieve our separation from the whole – a reference to birth – and, on the other, we fear the loss of self that we feel will come with death. Between these two time-related poles, there remains a persistent impression that deeper meanings might be found in a 'now' that somehow remains elusive.

Furthering his explorations of the space-time continuum and echoing ancient Buddhist teachings, Bullock developed new visual ways in the second half of the 1960s to challenge our conventional views that the world is full of static, separate, solid things. The venerated Zen teacher Eihei Dogen (1200–53) wrote in his essay 'The Time-Being': 'Because the signs of time's coming and going are obvious, people do not doubt it. Although they do not doubt it, they do not understand it. If time merely flies away, you would be separated from time.' In other words, our perception that time is passing before us belies the fact that we are actually active participants in the ever-changing process of living.

Throughout his career, Bullock made a few photographs that he called 'seed' pictures, images that, at the time of their making, were one of a kind, but later became the basis for the creation of a fully developed body of work. *The Pilings*, 1958 (page 58) is one such seminal photograph. With the aid of a neutral density filter, Bullock produced it by leaving the camera shutter open while he used an opaque card to cover and uncover the front of the lens, as one wave after another moved into the picture frame. The image resulting from this 'multiple time exposure' makes visible an ever-evolving world of movement and change that includes the concrete pilings as well as the water, the photographer and the viewer. It gave Bullock a primary strategy to extend his creative search.

Along with photographic montages such as *Leaves* (page 85), *Sea Palms* (page 79) exemplifies the imagery Bullock produced in the mid-to-late 1960s. What appears to be a motionless fog-shrouded valley is actually the visual rendition of an extended period of time as waves passed back and forth over rocks and intertidal plants on the California shoreline. Instead of waiting to

select a discrete slice of time to immortalize, Bullock allowed himself to be carried along both experientially and photographically. What we see are events in process, and what we have the opportunity to feel is both the awe and the comfort of being part of that process. In relation to this photograph, which is particularly evocative of certain oriental artwork, it is also interesting to note that Bullock's rapport with Eastern philosophy (especially the thoughts of Lao-tse) is matched by how much his work is valued in the Far East.

'If you stop searching,' Bullock once said, 'you stop living, because then you're dwelling in the past.' Never content to settle indefinitely into a way of working or thinking simply because it was productive, Bullock reached forward to growth once again in the late 1960s. As in every transitional period of his career, he read widely and photographed freely. Always keeping his camera close by, he tried to be as open and receptive as possible to what was around him. At times, what called to him was right in his own backyard, and at other times he would be attracted by something while he was running errands or simply driving around. Through the fullness and intimacy of his attention, what he created during this two-year period is a small group of quietly exquisite images, distillations of his experiences that are similar in feeling and effect to haiku poetry.

In terms of Bullock's reading and study, the work of Bertrand Russell regarding knowledge and the mind, and Alfred North Whitehead's process philosophy particularly intrigued him since they related so directly and mean-ingfully to his own experiences and thoughts. Stimulated by many of their concepts, he reworked, expanded and unified the ideas that had nourished his vision up to that point into two new associated principles. The first he termed

'reality and existence'. 'Reality for me,' he explained, 'is the known, it is of the senses-brain-mind. Existence is the unknown ... I experience reality. I believe in existence.' About this principle, he also wrote, 'My interest in defining the sharp difference I feel regarding what I call reality and existence stems from my deep involvement with the mysteries of the existential being of things.'

Fleshing out the distinction between reality and existence, Bullock set forth his second principle with these words: 'ordering and things ordered coexist yet have independent significance'. Corresponding to reality, 'ordering' embraces all activities of our senses and mind. When we interact with things, what we know and respond to comes from stimuli received through our physical and mental filters. Although these stimuli are not the things with which we're interacting, it is the existence of things – 'things ordered' – that makes them possible. Thus, the two opposites are inescapably linked, but they also have distinct meanings and implications. Our conscious world is the world of reality. It can be dull and restricting, or creative and expansive. It can have little relationship with things as they exist, or it can be closely and dynamically connected. What matters is how open and attentive we are in our perceptions, how flexible and conscientious in our conceptions. The more we are willing to work directly and responsibly to develop our own faculties, our realities, the more healthy, harmonious and constructive our relationships with existence can become.

As is true with his earlier principles, these last two not only serve to enhance our appreciation of his imagery, they also have more general applicability. It is not that they are startlingly original, for they are not. What is profoundly significant about them is their usefulness in promoting insight and growth. For Bullock, they compelled him to embrace the responsibility for his creative

functioning in new and empowering ways. He became even more intentional in his open interactions with things, more probing and inquiring, more zestful and imaginative. Striving to expose and go beyond his own entrenched assumptions and limitations, he discovered that greater responsibility actually brought greater freedom.

In what was to become the final stage of his life, Bullock enjoyed three enormously exciting and productive years of making photographs. To match his heightened abilities to experience and know, he developed his expressive skills to an unparalleled level. His last body of work includes 'straight' photographs as well as those that have been printed with their tones reversed, those printed with their directions reversed and those printed with both tones and directions reversed. One of the most impressive aspects of Bullock's artistic and technical mastery during this time is that the ways in which he created his pictures are such an integral part of their meaning that one is not aware of them as techniques. This was vitally important to Bullock: he was using the medium of photography to go beyond conventional ways of seeing and understanding and say, 'This is real, too.'

As human beings, we have a fundamental choice: we can either search for meaning within the realm of what appears to be real, or we can challenge the limits of that reality by asking if there might not be something more. Throughout his life, Wynn Bullock asked this question, and, by listening carefully, left us with a legacy of inspiration and wonder.

Girl, 1939. Throughout his creative life, Bullock sought effective ways in which to extend the meaning of his work beyond the familiar. During the early years of his career as a photographic artist, he experimented with a number of alternative processes, which were often boldly dramatic. Later, his methods became more subtle. Here, he applied the technique of solarization to give this portrait of a young woman a dark, mysterious intensity.

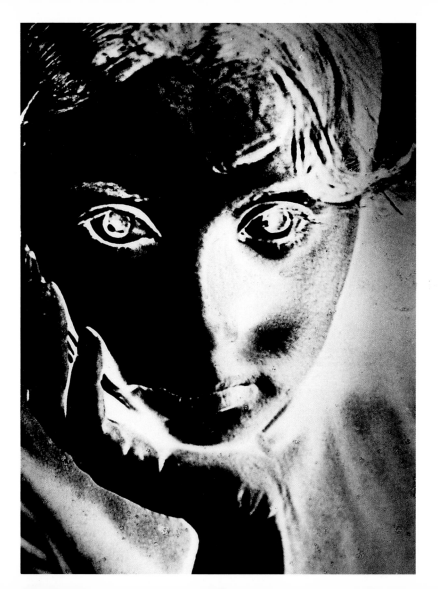

Early Solarization, 1940. Solarization occurs when a photographic print is exposed to light while developing. This technique was frequently utilized by Man Ray. In Bullock's ethereal photograph, the radical reversal of tones causes luminously graceful hands to float in a field of brilliant light.

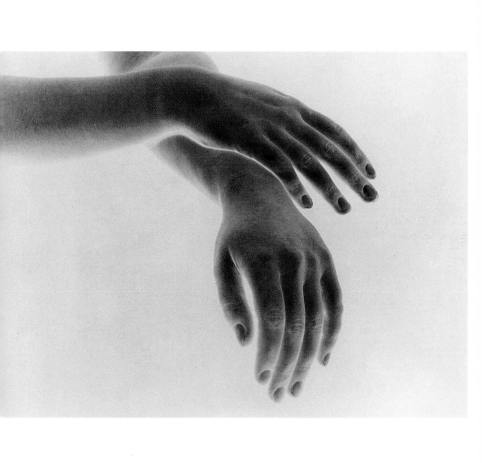

Reticulation, c.1949. Students are taught to avoid reticulation (the break-up of the film emulsion) by ensuring that the temperatures of their photo-chemistry are consistent. By deliberately allowing reticulation to take place, however, Bullock was able to create an intriguing abstraction, reminiscent of the work of Paul Klee and Vasili Kandinski, two artists whose thoughts and art enriched his own.

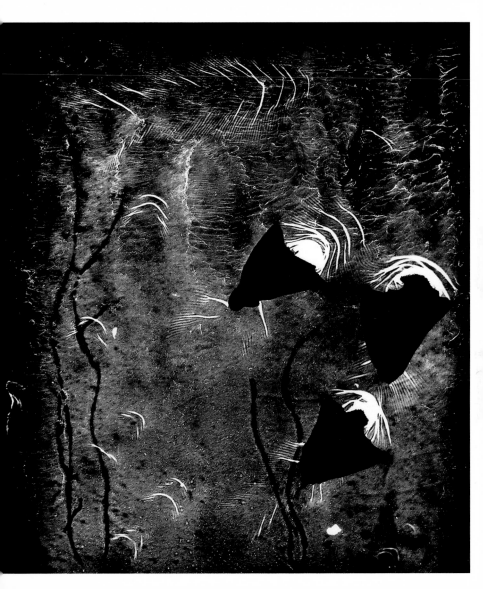

Child in Forest, 1951. This photograph of Bullock's daughter was one of the most memorable and controversial images in the historic 1955 'Family of Man' exhibition mounted by Edward Steichen at the Museum of Modern Art in New York. While many viewers were moved by the quiet beauty of the image, some saw it as a disturbing portrayal of a dead or abandoned child. Responding to often very emotional queries about the picture's meaning, Bullock said: 'It was an ancient virginal forest. Barbara was a young virginal child. I knew immediately the qualities of her body would both contrast and harmonize beautifully with the qualities of the dead logs and living plants of the forest. The cyclic character of natural forces would be clearly evident. The light was just right and the relationships between events were strong and exciting. All I had to do was set up and take the photograph.'

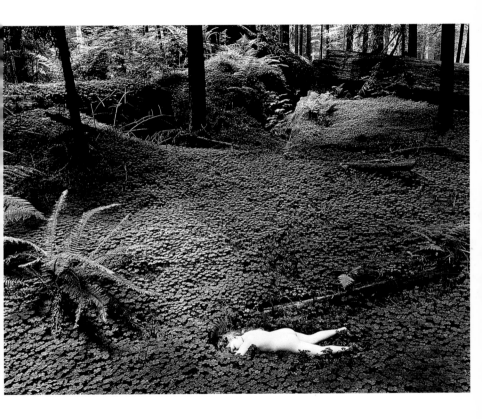

Old Typewriter, 1951. Near the edge of an old road leading to a deserted lumber camp, Bullock found this common artefact falling back into nature through the inexorable process of time. His photograph witnesses universal forces in action and is a powerful symbol of some of the ways in which humanity and the rest of nature are essentially linked.

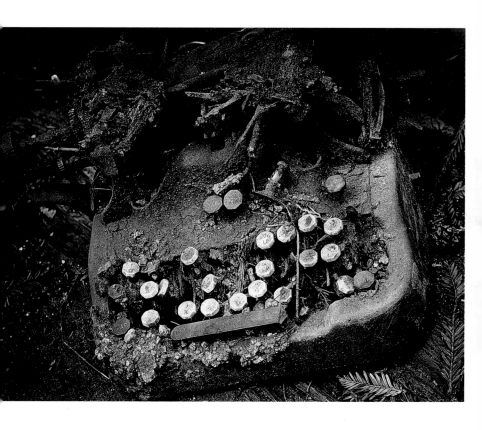

Worn Floor, 1952. Through a doorway, sunlight falls softly into a room, only partially revealing the interior space. We can clearly see that many feet have passed over this floor. Is the open door an invitation to step outside or to come in? Either way, what lies waiting to be discovered? What is present here and now? The transition from the known to the unknown is a recurrent theme in Bullock's photography. 'Mysteries lie all around us,' he said, 'even in the most familiar things, waiting only to be perceived. If I photograph in such a way that I meaningfully evoke a sense of the known and the unknown, I feel I have succeeded.'

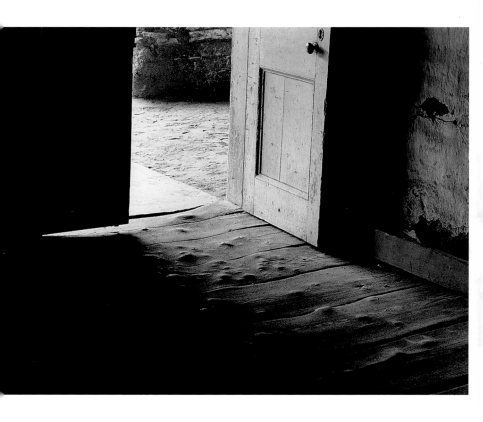

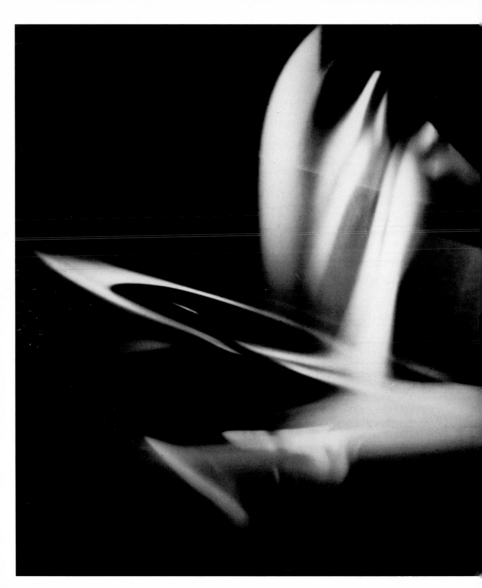

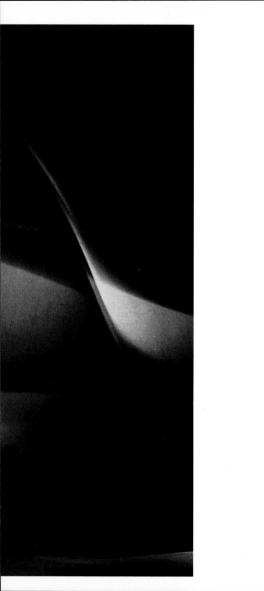

(previous page) **Light Abstraction #3, 1952.** Bullock once wrote, 'Instead of using the camera only to reproduce objects, I wanted to use it to make what is invisible to the eye visible.' If light is the fundamental element of both seeing and photography, how might it be possible to make an image with light and nothing more? This photograph is an early exploration into the phenomenon of light itself, an exploration to which Bullock would return with greater focus in the early 1960s.

Half an Apple, 1953. Firm, fleshy, glistening with juice, this is an apple you want to eat. Looking at it from another perspective, the centre of the halved fruit reveals a face-like form, raising the suggestion that humanity can be seen as an integral part of nature. Although Edward Weston's iconographic photographs of vegetables and fruits may have influenced this image, there are elements of symbolism that make it uniquely Bullock's own.

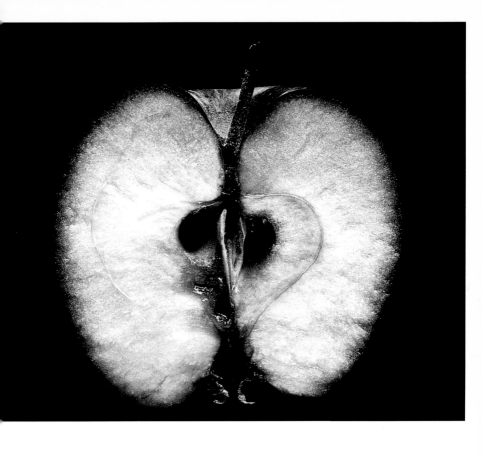

Nancy at Point Lobos, 1953. This photograph is among the early examples of Bullock's figure work that do not include members of his family. In relation to working with any person, he said, 'My pictures are never pre-visualized or planned. I can't anticipate the mood of the model, how she will react to a particular place, what the character of the light will be, or how I myself will respond to all these things. I feel strongly that pictures must come from contact with things at the time and place of taking.'

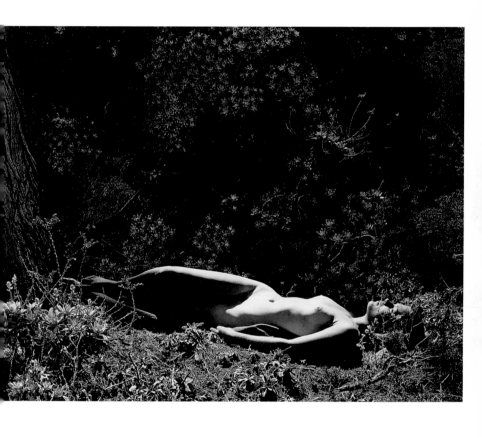

Nude on Log, 1954. Although this photograph clearly celebrates the beauty of the female form, the meaning of the image goes far beyond this. During the 1950s, when he made most of his nudes, Bullock was quoted as saying, 'I feel all things as dynamic events, being, changing, and interacting with each other in space and time even as I photograph them.'

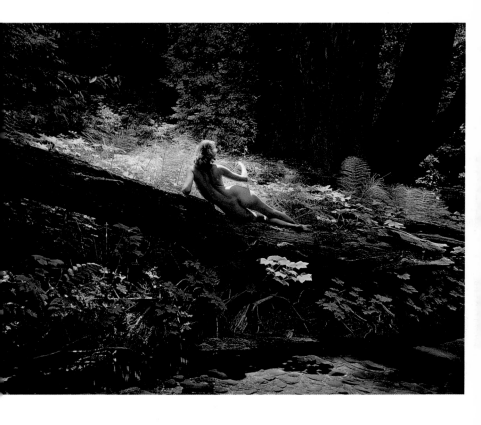

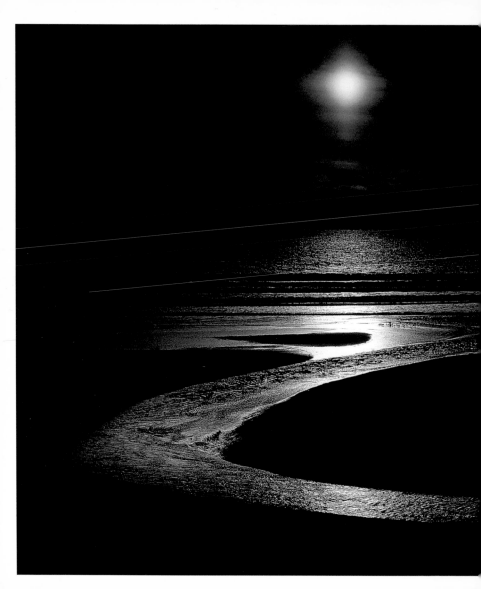

(previous page) Let There Be Light, 1954. This image was a popular favourite in 'The Family of Man' exhibition and helped Bullock achieve wide recognition. Although it is an exquisite depiction of light and the beauty of natural patterns – elements often found in Bullock's photographs – he was somewhat disappointed by the sentimental response it elicited from many viewers.

Stark Tree, 1956. 'Discovering the concept of space/time', Bullock said, 'and applying it to photography doesn't guarantee good pictures, but, for me, it represents a tremendous leap forward. Through it, I am learning about form, balance, energy, light, perception, uniqueness, connectedness, change, interdependence, and how, through an awareness of tones and opposites, I can create powerful symbols of my experiences with these things.'

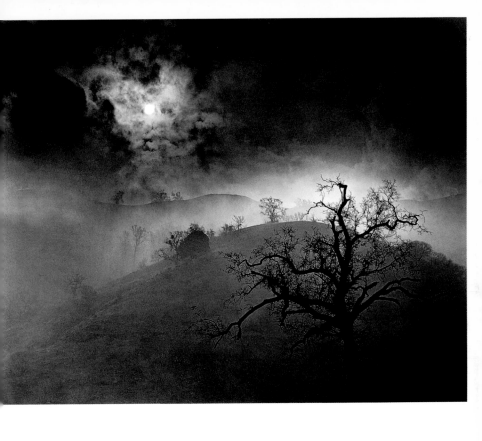

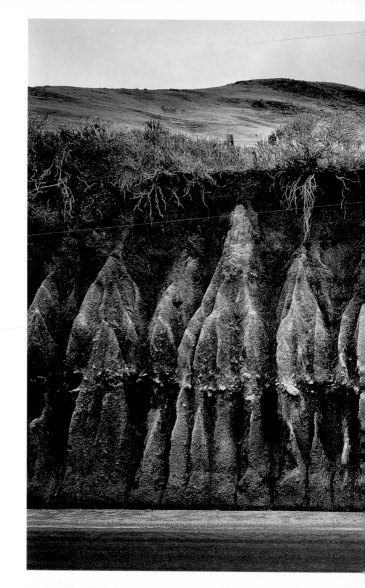

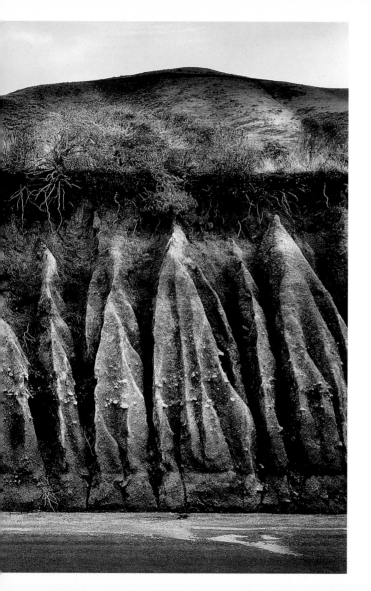

(previous page) Erosion, 1956. If truth often exists beneath the surface of the familiar world, then this photograph becomes a clear metaphor for this insight. What is normally hidden from our view is revealed. The mysterious and unknowable have been visually evoked. This ability to make direct photographs work as powerful symbols of what is beyond our ordinary senses is one of the great strengths of Bullock's imagery.

Night Scene – Nude in Window, 1956. There are many clues that this was taken during the day, but the feeling of night that Bullock created in the darkroom radically alters the mood and meaning of the image. For him, the creative process did not stop with the camera. 'I'm not a purist,' he said. 'In printing, I will go to any trouble to get the feeling I want.'

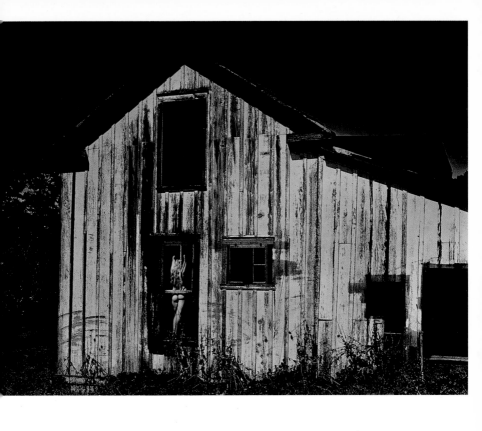

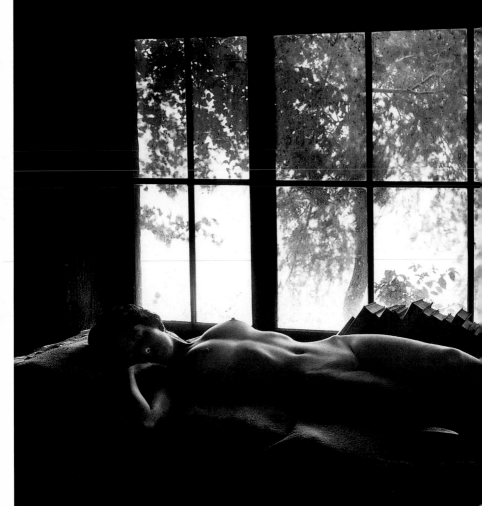

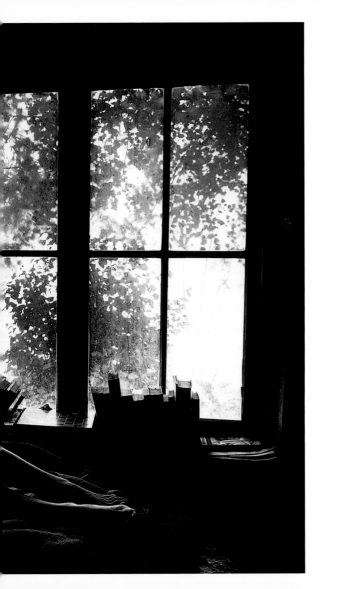

(previous page) Nude by Sandy's Window, 1956. The contrast between this and the next photograph reveals a great deal about the different ways in which fantasy and reality can evoke erotic sensations in art. Like Goya's famous nude *Maja*, this image is clearly a homage to the almost surreal beauty of a woman actively participating in the act of being seen and admired.

Marilyn with Cat, 1956. The natural ease of this woman's pose and surroundings conveys a trust and innocence that we can actively enter into and appreciate. On the other hand, for some viewers, the image is a potent example of the classic photographic fantasy of invisibility, in which the model's seeming unawareness of being watched adds a voyeuristic tension to the meaning of the photograph.

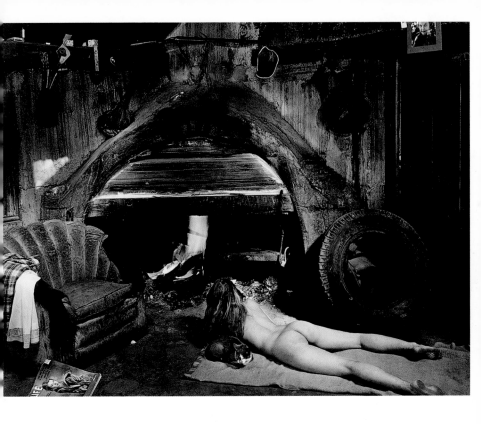

Edna, 1956. 'Words, photographs, paintings, and sculptures', Bullock wrote, 'are symbols of what you see, think, and feel things to be, but they are not the things themselves. To the degree symbols express the structure of the real world, they are meaningful. In my photography, therefore, I strive to come as close as I can to experiencing things as they are and to express visually the totality of those experiences in the strongest, most accurate ways I can find.' In this work, a simple image of his wife's breasts and hands becomes an expressive symbol of an older woman's beauty and grace.

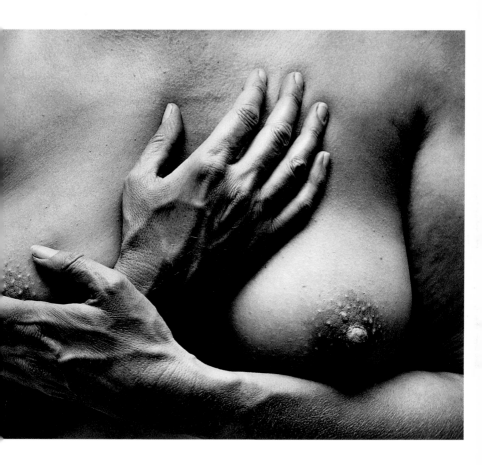

Cactus, 1958. When asked to submit a photograph to a major exhibition based on the theme of 'Love', Bullock sent this image. The curators chose it as the title photograph of the show.

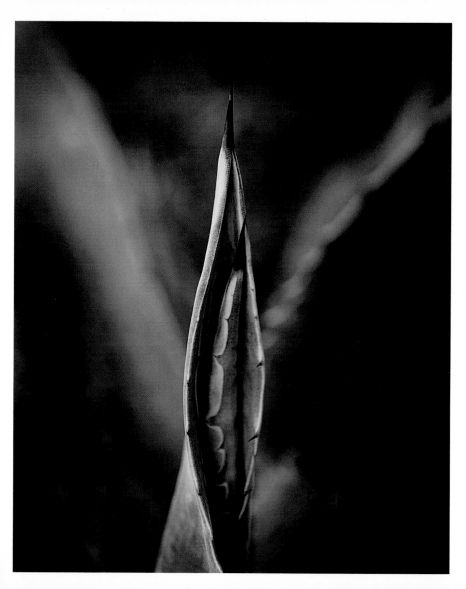

Navigation without Numbers, 1957. Perhaps the most important thing to note about this haunting photograph is that it was not fabricated by the artist. The woman was a waif who had been given shelter by the caretaker of a remote ranch in Big Sur. It was a favourite site for Bullock and he had become friends with her, occasionally giving her work as a model. Earlier in the day, Bullock had been shaken by a strong premonition that she would eventually be forced to give up her son. When she put him on the bed for a nap and then moved to the edge of it, the premonition seemed to come to life before his eyes. It should also be noted that the book on the window sill that gives the photograph its title is a classic text on how to make one's way across dark waters.

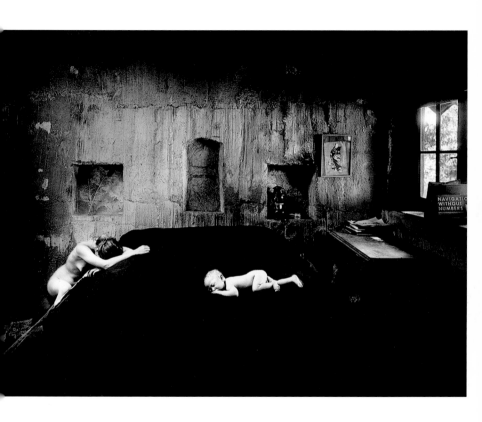

Point Lobos Tide Pool, 1957. Among all the photographs made at Point Lobos, this remains one of the most profound. On both macrocosmic and microcosmic levels the infinite complexity and awesome depth of the universe is evoked by the dense array of algae and organic filaments floating on the surface of the pool. For Bullock, much of the personal meaning of this image rested on the fact that the very instant after he released the shutter of his view camera, a gust of wind totally obliterated the patterns he had just photographed.

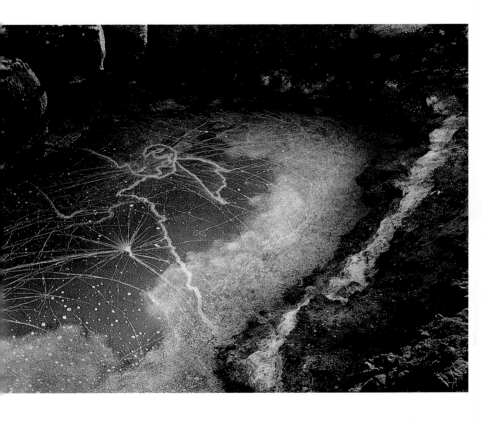

Lynne, Point Lobos, 1956. Bullock often photographed around family picnics and outdoor celebrations. 'I'd work all morning with my camera, and Edna and the girls – if they weren't modelling for me – would be off hiking or reading or playing games. Then around noon we'd all gather together ... I would tell them what I had seen, and they would share what they had found. It was all part of the joy of the day.' This photograph, taken during a special party outing, records a moment in his youngest daughter's life. Primal forces confront the child. Although wary, she turns to face the sea. What happens next is left to our imagination. It is an image that invites us to reflect on our complex relationships with the natural world.

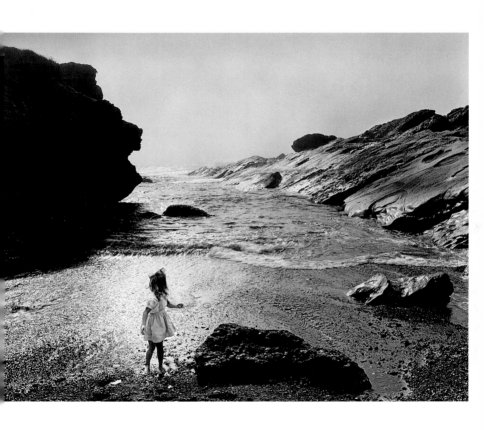

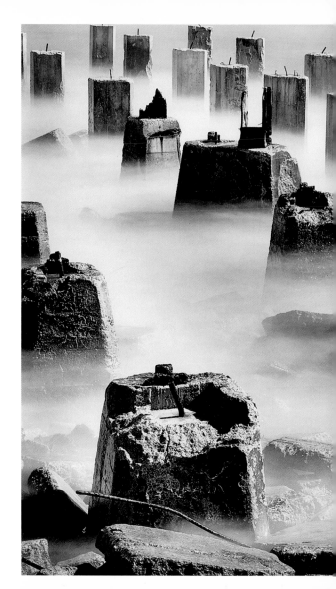

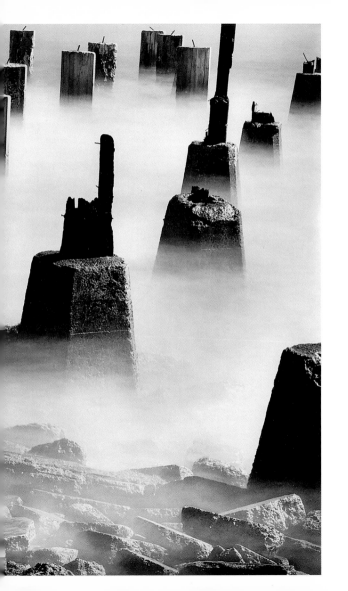

(previous page) **The Pilings, 1958.** This image represented a new approach for Bullock in his exploration of the dimension of time. What he photographed were waves passing back and forth over pilings during a long camera exposure. What we are given is an experience of the passage of time — of past, present and future dynamically linked together — and of distinctive events (water and pilings) interacting with and defining each other.

Boy Fishing, 1959. Look closely at this deceptively simple photograph and you find both irony and insight at play. The boy (who is holding a fishing pole) is standing in the midst of complex spatial and temporal relationships of which he is an unsuspecting, yet integral, part. It is the photographer's awareness of the totality that gives this image its intriguing power.

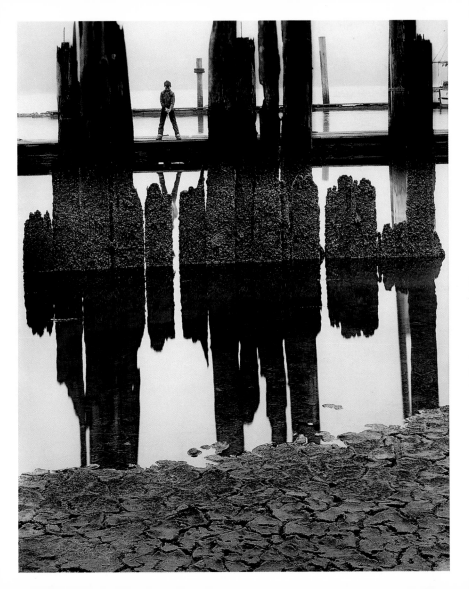

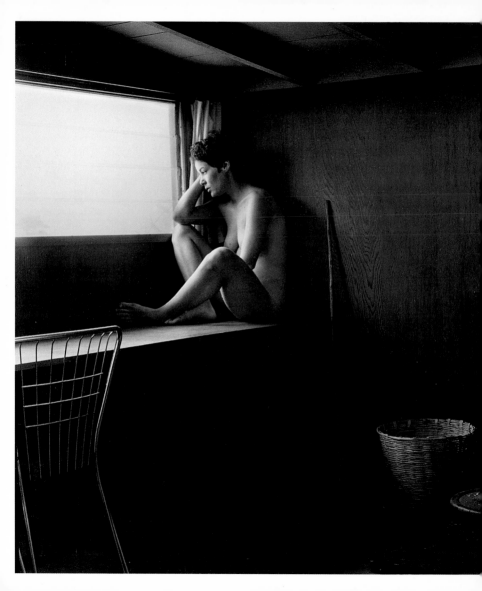

(previous page) Kay, 1958. Few conventional portraits exist within the core of Bullock's fine-art work, but this image and the next one represent his responses to the lives of two specific individuals. Dominated in a relationship with an unscrupulous man, Kay was a lonely, troubled young woman. In this photograph the fireplace contains only cold ashes and the room is barren, creating a setting that tells the story of her circumstances. The broom, empty wastebasket and lighted window are all ambiguous symbols that add to the richness and poignancy of the portrait.

Girl in Car, 1960. In this image, Bullock comes as close as he ever did to what could be called a documentary approach to photography. He found this brooding young woman sitting in an old, dirty car and was moved to take her picture. He knew nothing about her beyond the visible facts presented at that moment.

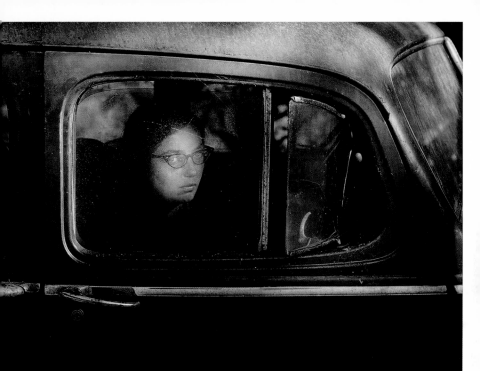

Color Light Abstraction, c.1960. During the first half of the 1960s, Bulloc engaged in a concentrated exploration into the phenomenon of light, not as a illuminant, but 'as a force and an entity in its own right'. It was the only time i his creative career that he worked in colour. His 'color light abstractions' hav rarely been published or exhibited, partly because of the limitations of colou technology that existed during the period in which he was producing them, an also because they simply look different from the rest of his imagery. Bullock however, was truly a visionary artist. When his work is considered in its entiret these pioneering images form an integral part of his creative journey.

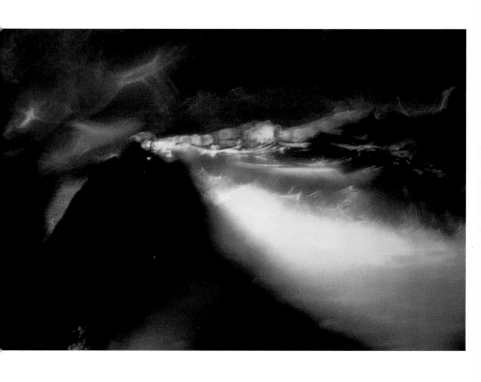

Color Light Abstraction, c.1960. Bullock worked with an old 35mm Exacta camera with a dual-rail close-up bellows attachment and Kodachrome II Tungsten film. Utilizing a homemade stand that held several layers of clear glass, he would place on the topmost panes fractured pieces of optical glass from an observatory lens. On the lower levels he would arrange shards of stained glass and crumpled sheets of bright cellophane. Other light-refracting materials, including honey and droplets of water, might also be added. Surrounded by photofloods, spotlights, and prisms, Bullock would then bring his camera lens sometimes as close as $\frac{1}{16}$ of an inch to the subject matter. He would create his pictures by manipulating all the different elements and controlling the focus mechanism so that object reality was lost.

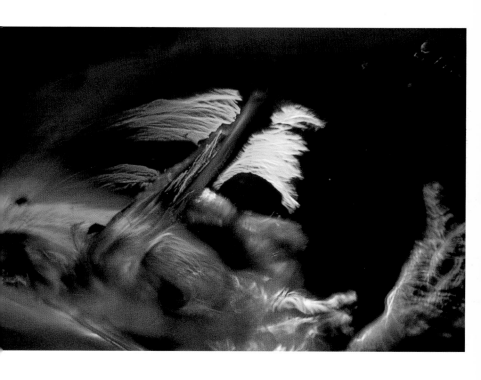

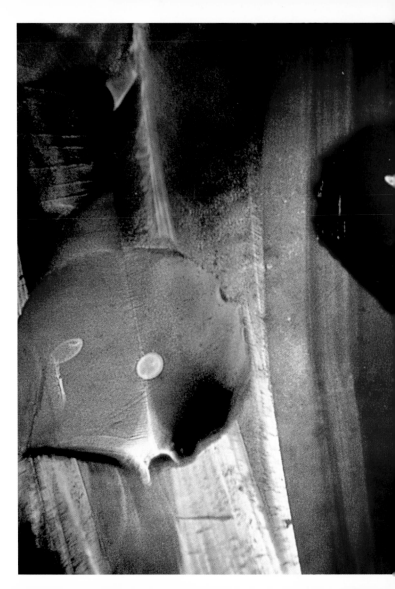

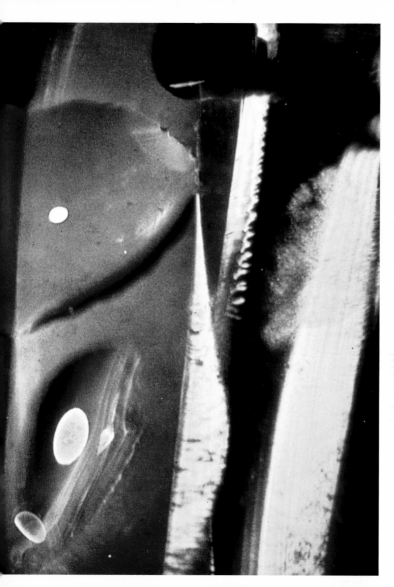

(previous page) **Color Light Abstraction, c.1960.** Referring to these images Bullock once said, 'light used in its own right, gives to photography the wonderfu plasticity that paint gives to painting without loss of the unmatched reality o straight photography'.

Color Light Abstraction, c.1960. For Bullock, light was 'perhaps the mos profound truth in the universe'. Through these photographs, he felt he was abl to give expression to some of his deepest feelings and beliefs.

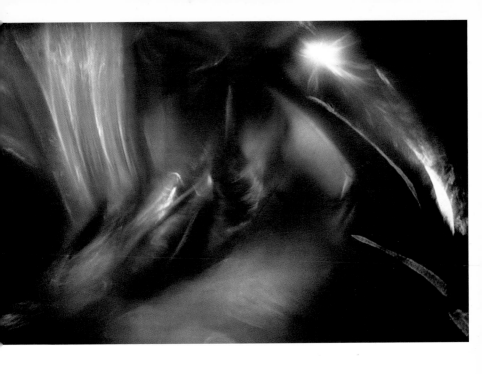

Cannery Row, 1966. When he had reached a point of natural completion with his colour work, Bullock began an intense period of study and reflection, a practice in which he frequently engaged to refresh and renew himself. He said, 'Theoretical scientists who probe the secrets of the universe and philosophers who seek answers to existence, as well as artists such as Paul Klee who find science compatible with art, influence me far more than most photographers. My interest in such people is to share in their wonderment of nature, and, in sharing, find added inducement to go out, look, feel, and photograph.'

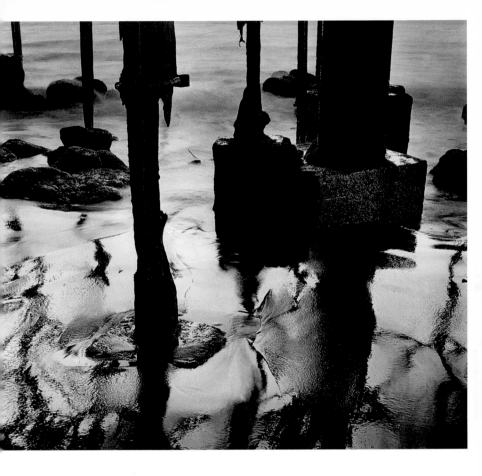

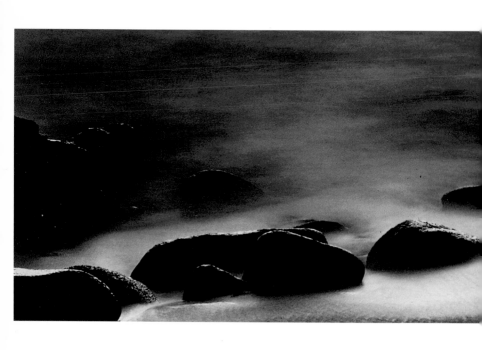

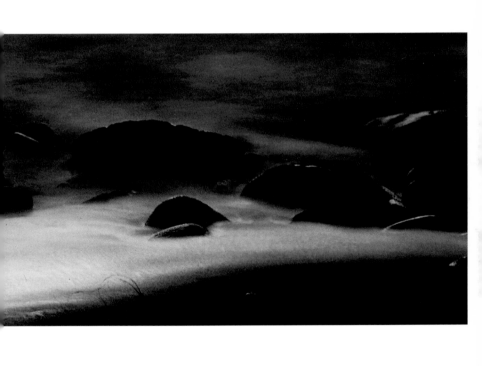

(previous page) Rocks, Sea, and Time, 1966. 'Since the earliest cave drawings,' Bullock wrote, 'pictures, in order to have any significant meaning ... must have magic, a magic that evokes experiences apart from the material.' When he resumed his black-and-white photography in the mid-1960s, he reconnected with the sea and created just this kind of magic.

Sea Palms, 1968. Many seeing this image for the first time believe it to be a mountain valley filled with fog. In fact, it is a relatively small set of wave-swept rocks and intertidal plants. At this point in his life, Bullock was experiencing the flow and depth of change, its fullness and continuity, with new richness and power. Through experimentation with equipment and technique, he developed ways to symbolize these experiences in which the means, rather than being intrusive, became an integral part of the 'magic' and meaning of the photograph.

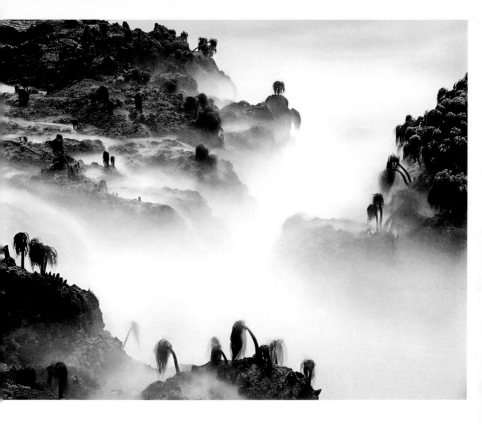

Mendocino Coast, 1968. Despite the eloquent beauty of this photograph and others like it, Bullock did not make photographs using long, multiple-time exposures after 1969. Although the technique allowed him to grow as an artist and create a small, stunningly expressive body of work, he felt that additional images would begin to appear stylistic and lose their potency as symbols. Throughout his career, Bullock rejected complacency. Simply because something worked well was not sufficient reason to continue doing it indefinitely. He was always seeking to expand his abilities to experience, understand, see and make meaningful photographs.

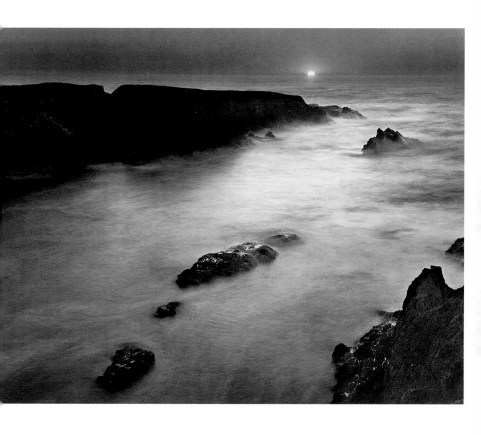

Foggy Forest, 1969. Bullock believed that space is fullness – that there is no such thing as 'empty space'. Air, light, sub-atomic matter, relationships among events, all help define this fullness, and in this image, the fog serves as a metaphor for his belief.

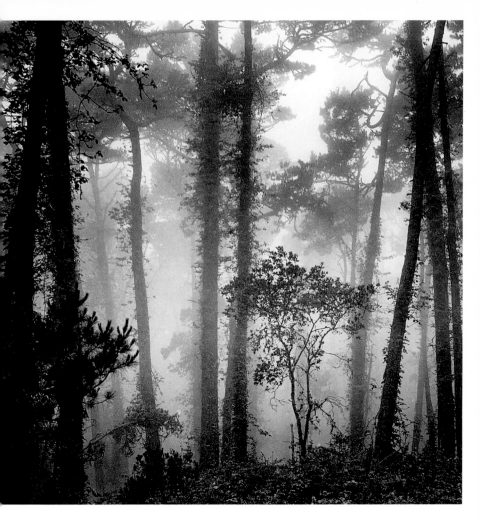

Leaves, 1967. Here, three loquat leaves appear in varying stages of decay. One still retains much of its form intact. The second is more ghostly, and the faint outline of a stem and base are all that can be seen of the third. Like Bullock's long time exposures, this is an image in which he found a way (this time using superimposed negatives) to intensify the experience of the process of time and change.

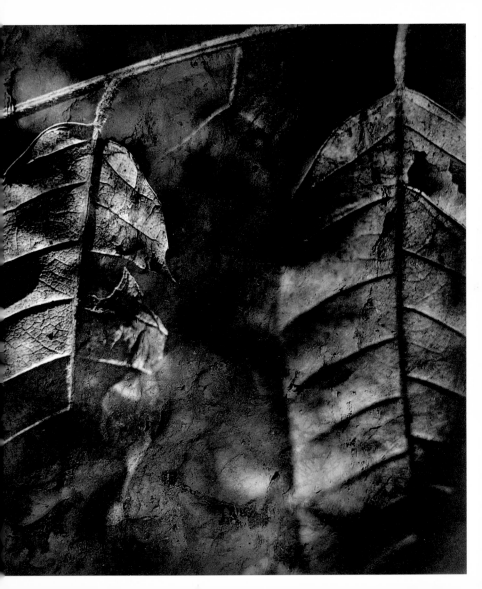

Leaves and Cobwebs, 1969. In 1969, Bullock was once again in a period of creative transition, gradually leaving behind his superimposed and time-controlled imagery and moving towards what was to become his last body of work. What characterizes this and the following four images is a quiet essence similar to that experienced in haiku poetry. At the time, Bullock's wish was simply to experience everything around him as openly and receptively as he could, and to express his experiences on film with as much fullness and immediacy as he was capable of producing.

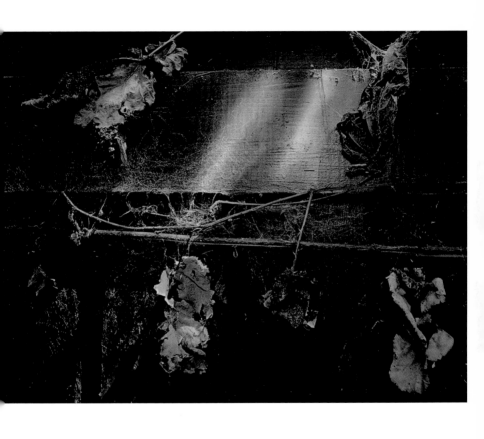

Tail Lights, 1968. In this photograph, the lines, planes, textures and tones of an old abandoned car are rendered in exquisite detail. The way in which its temporal qualities are manifested through a delicate section of cobweb, layers of grime and blistered surfaces, silently yet powerfully engages our emotional responses.

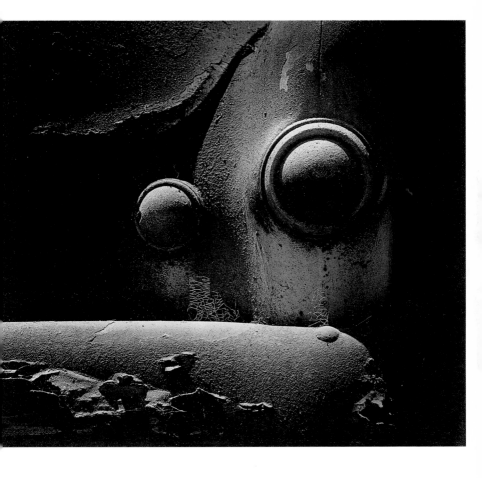

The Lamp, 1969. During the period in which this image was made, Bullock would load his equipment in the car and head out to deserted sardine factories, rocky coves, old cemeteries, country roads ... wherever his spirit led him. Stopping frequently, he would wander about until something caught his attention. He would then focus intently with his whole being, entering into a kind of meditative relationship with his subject. A concert singer prior to becoming a photographer, Bullock attributed much of his success in both professions to his powers of concentration and empathy.

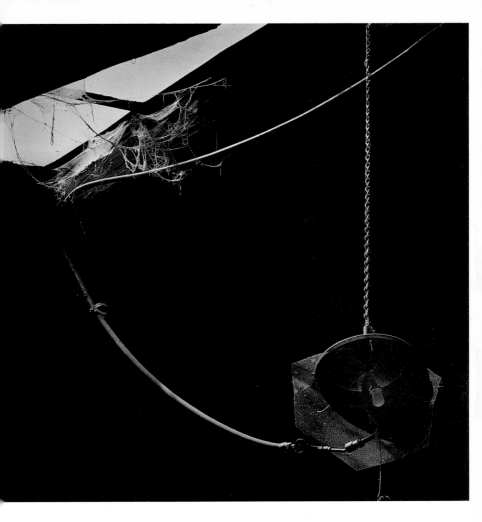

Untitled, 1970. 'The tonal brilliance of a fine print is not an end in itself,' Bullock said. 'At best it evokes a sense of light. Not alone the light that permits us to see things, but light ... as a great and beautiful force.' The aesthetic and symbolic qualities in this simple, direct image of peeling paint reveal much about the phenomenon that so intrigued and inspired him.

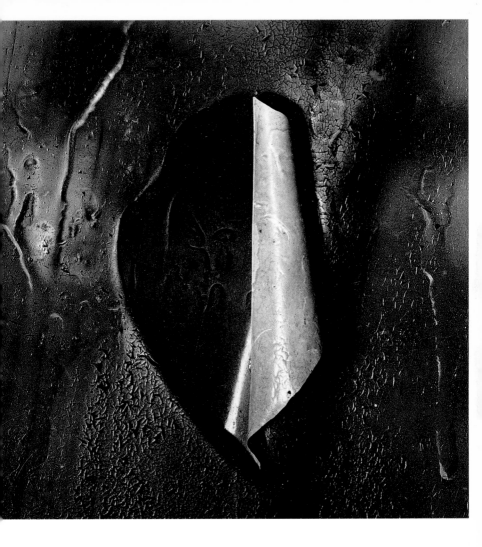

Wheat and Shadow, 1970. This image belongs to the previous group of four photographs not only by virtue of its date, but also in terms of its quiet simplicity. Its unusually enigmatic meaning, however, sets it apart from the others. Bullock left few clues to unravel its mystery. What we do know is that the stalk of wheat reminded him of a Native American peace pipe and that the shadow is his own.

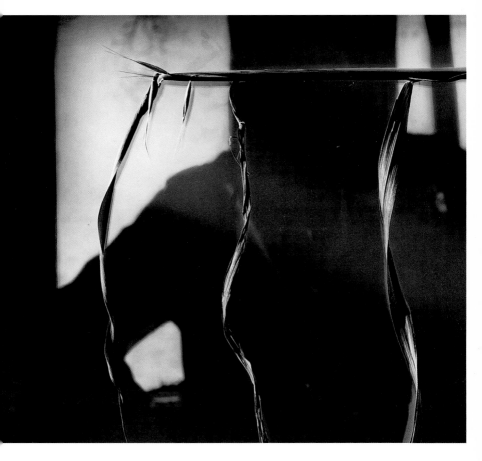

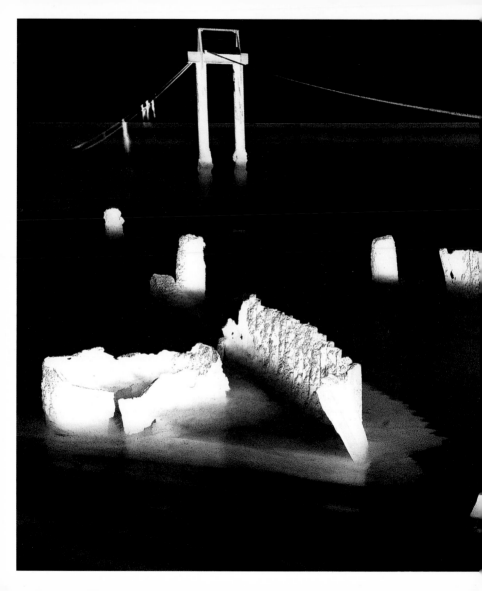

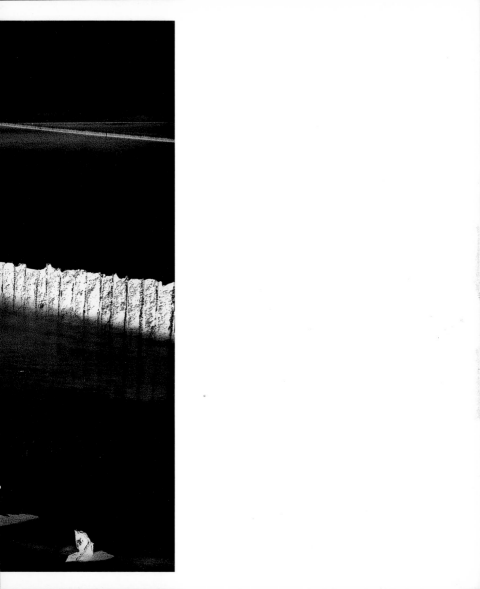

(previous page) **Offshore, 1970**. This photograph represents the early stage of Bullock's exploration of reversal printing as a way of using the opposite of something familiar to probe its meaning more deeply. Printed in this way, scene of water and remnants of an old wharf surprises us with its depiction of rotting wood pilings alive with brilliant inner energy.

Untitled, 1970. The remaining photographs in this collection represent the last and, in many ways, most spiritually productive period of Bullock's creative life before his death from cancer in 1975. They are the culminating expression of two great themes in his work: the nature of existence and the human being's place in the universe, not only as an entity belonging to it, but also as perceiver and creator of meaning within it.

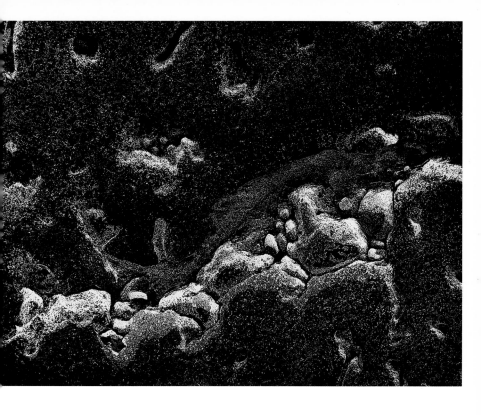

Untitled, 1970. Bullock believed that 'what you see is real — but only on th particular level to which you've developed your sense of seeing. You can expan your reality by developing new ways of perceiving.' Through his final photographs he ventured far beyond our 'normal' way of seeing and understanding the realit of things to give us a glimpse of what our world and the universe might look lik if we could see the forces that animate and sustain them.

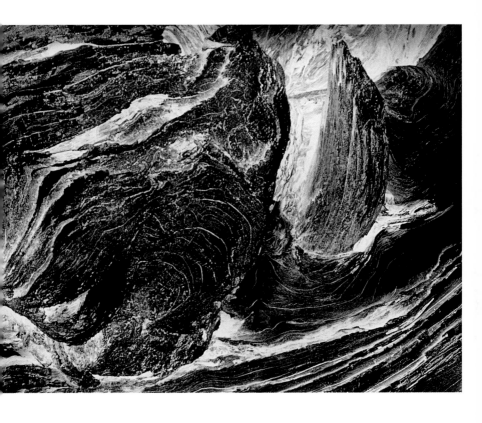

Landscape, 1970. Here, Bullock uses reversal printing to create an image that suggests a mountain vibrant with energy and life. 'When I feel a rock is as much a miracle as a man,' Bullock said, 'then I feel in touch with the universe. Not the object rock, not the form rock, but the light that is the rock.'

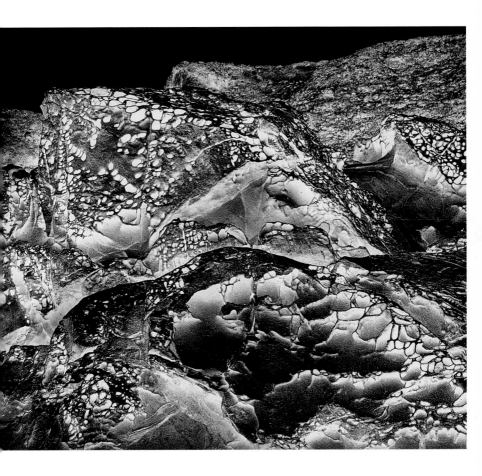

Pebble Beach, 1970. This photograph is another example of a negative print: what we see here is the tonal reverse of the positive original. How it was made, however, does not intrude on our visual experience of the image, and this was important to Bullock. For some, this is a picture of fertility, generation and abundant life. The fact that these qualities are expressed through rock – a rock filled with seed pebbles aglow with new life – only serves to enhance and extend our appreciation of them.

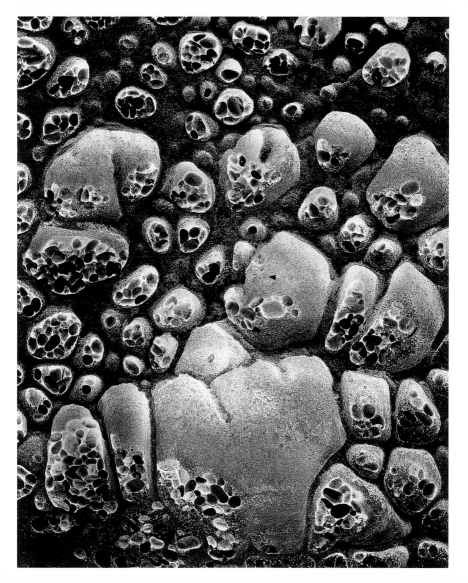

Pebble Beach Fantasy, 1970. As an aid to visual discovery, Bullock trained himself to see upside down — not through his viewfinder, but naturally through his eyes and mind. By expanding his perceptual powers in this simple way, he was able to create photographs that not only stimulate and inspire us intellectually and emotionally, but also challenge us to overcome our habitual ways of seeing and responding to things. Turn this image upside down and it becomes a rather ordinary photograph of eroded rock, stones and sand. Seen the way Bullock intended it, however, a humanoid form emerges and the image becomes a symbol of humanity's oneness with nature.

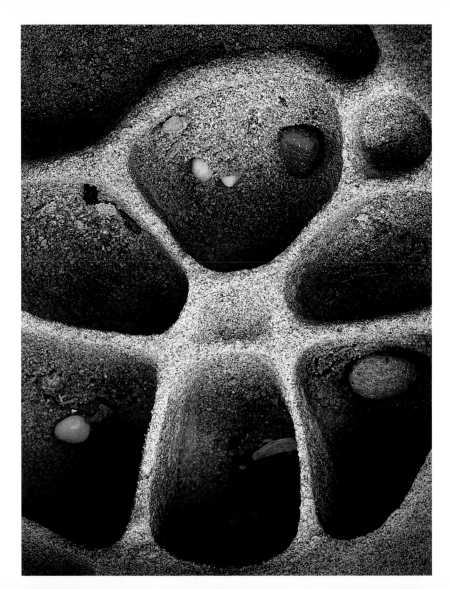

Rock, 1971. 'My interest in defining the sharp difference I feel regarding what we call reality and existence,' Bullock wrote, 'stems from my deep involvement with the mysteries of the existential being of things.' This negative print, like that on page 99, evokes the presence of those mysteries. We cannot be quite sure what he is actually photographing here. Although it seems familiar, we cannot easily identify it. What Bullock gives us in this image is a visual opportunity to feel the mystery of things beyond our capacity to know them – the mystery of existence itself.

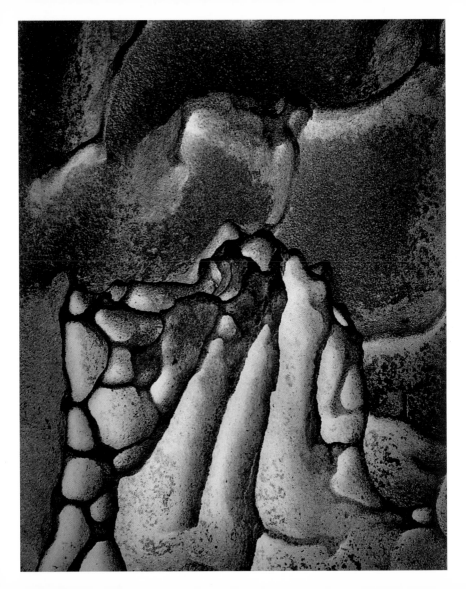

Point Lobos Tide Pools, 1972. To appreciate the difference between the photograph that Bullock created and the one most of us would take, simply turn the book around. This is another of his upside-down images, and this time we are presented with a new and intriguing landscape, a world that challenges established views of how things are or 'should' be.

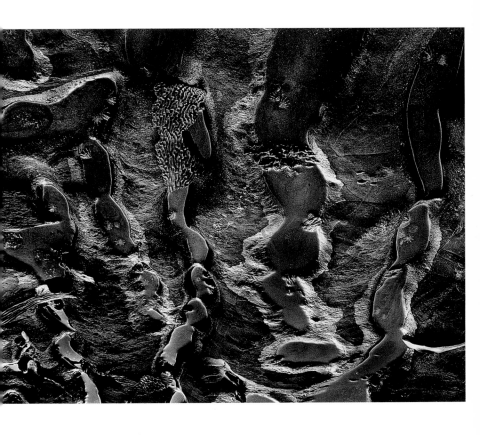

Tree Trunk, 1971. When Bullock found this tree, he saw further than the portion of gnarled and twisted cypress trunk that a traditional, positive photograph would have revealed. As he exposed his film, he envisioned the negative inverted image presented here. For Bullock, this is a picture of the light and energy that is inherent in all life. It is a picture of being and becoming, a potent visual symbol of what Alfred North Whitehead and others in the areas of philosophy, theology and cosmology refer to when they use the term 'process'.

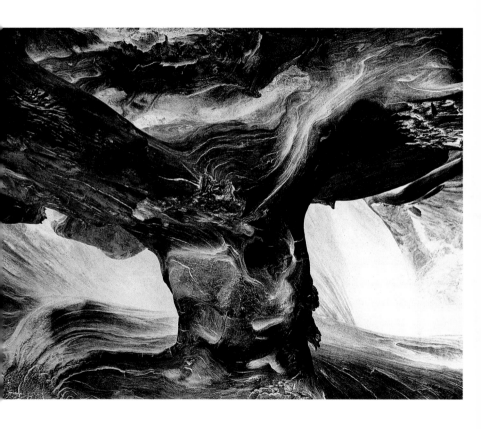

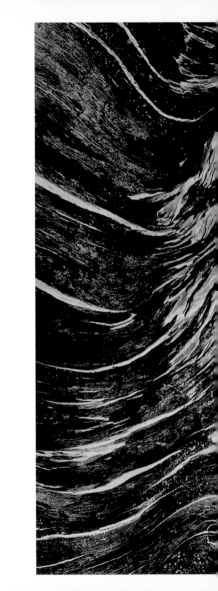

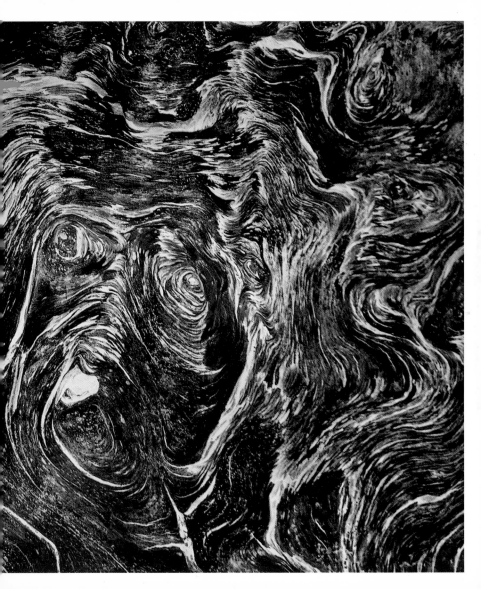

(previous page) **Untitled #1, 1972.** Here, the two major themes of Bullock's last body of work merge into a single image. In the radiating and swirling lines of energy, great universal forces seem to be at play, and in their midst a face emerges. Although relatively small in scale, the photograph represents a monumental vision of creation and relation.

Wood, 1973. From one perspective, turbulent forces can be seen flowing through this image, and from another, they can be seen forming the shape of a sentient being howling its emotions. If one relates the two perspectives, the being can be interpreted as responding intensely to forces that have the power to create, destroy and transform. It is an image rich with open-ended symbols.

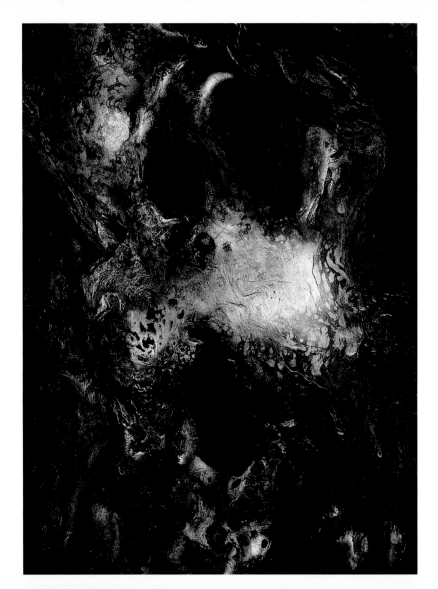

Sawed Tree Trunk, 1972. Like the previous photograph, this is a straight, close-up, positive image. And like other images from the last period of Bullock's photography, it carries a similar magic and symbolic power. Though it depicts a roughly sawn-off, burnt tree trunk, there is no hint of lifelessness. Lines of light surround a womb-like form, and other shapes also suggest potential life. In this image, death is not an end but rather a part of the process of continuity.

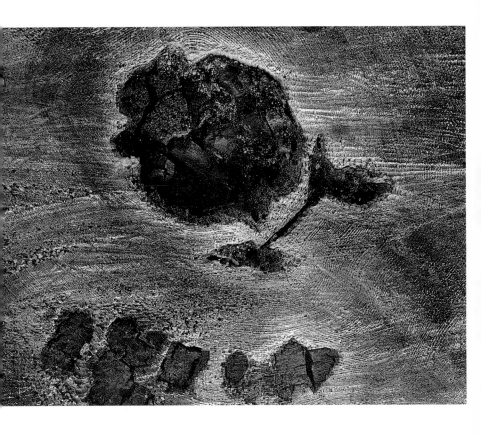

Wood, 1971. This image embodies the themes of Bullock's late work in provocative ways. 'Searching is everything', he said, 'going beyond what you know. And the test of the search is really in the things themselves, the things you seek to understand. What is important is not what you think about them, but how they enlarge you.'

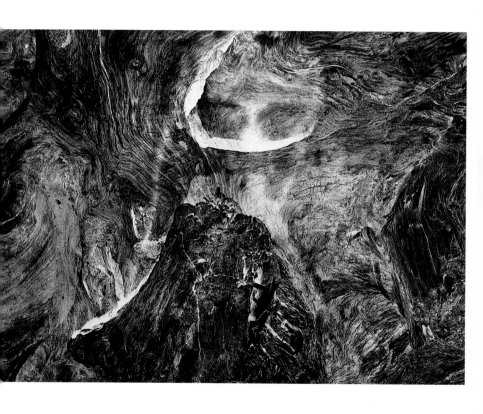

Fallen Tree Trunk, 1972. Bullock once explained that 'it is not that I am uninterested in telling visual stories about people and their everyday lives. I just like to leave this kind of work to others. What I prefer is to trace the hidden roots of humanity deeply embedded in nature.' In the last few years of his life, Bullock's depiction of this interconnectedness became even more explicit.

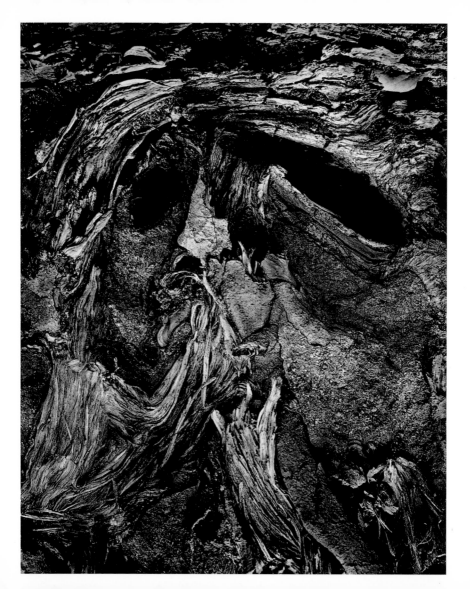

Rock, 1973. The rock is connected to its surroundings by light, light streaming into it and light pouring forth from it. The face in the rock is quietly intent, perhaps probing the mysteries of the universe. Its quest is not onerous, however. A hint of a smile indicates the richness and joy of the journey. In referring to photography as a way of life, Bullock said 'I see my work as a manifestation of positive thinking, of positive beliefs in the powers we have and can develop to create good. The urge to create, the urge to photograph, comes in part from the deep desire to live with more integrity, to live more in peace with the world, and possibly to help others do the same.'

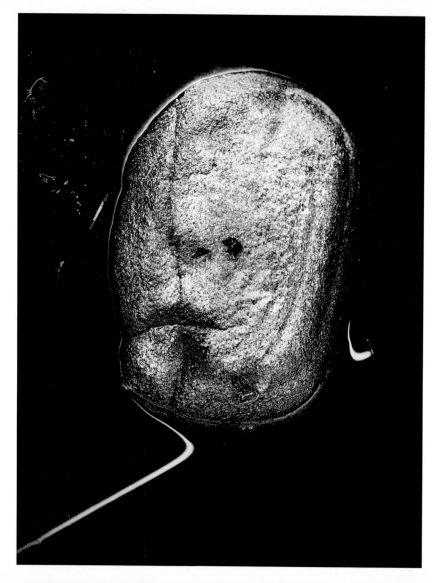

1902	Born Percy Wingfield Bullock, 18 April, Chicago, Illinois. Brought up South Pasadena, California. Discovers gift for music. Studies voice and begins singing professionally.
1921–1927	Moves to New York City to pursue career as concert singer. Marries Mary Elizabeth McCarty and has two children, Mimi (b.1930) and George (1935–42). Marriage ends 1941.
1927–1930	Moves to Paris to work with renowned voice coach. Discovers work of Impressionists, post-Impressionists, Moholy-Nagy and Man Ray. Has transformative experience and begins to photograph. Continues voice training and concert performances.
1931–1937	Returns to US to manage wife's family business. Stops singing professionally. Becomes increasingly absorbed with photography. Heavily influenced by work of semanticist Alfred Korzybski.
1938–1940	Moves back to California. Embraces photography as new career. Graduates from Los Angeles Art Center School, concentrating on experimental processes.
1941–1944	Awarded Los Angeles County Museum of Art's first one-person photography exhibition. Marries Edna Jeanette Earle and has two children, Barbara (b.1945) and Lynne (b.1953). Works as a commercial photographer while researching scientific and commercial applications of solarization.
1945–1946	Obtains photographic concession at Fort Ord military base. Settles in Monterey and handles all types of commercial work.
1946–1948	Awarded patents for controlling line effect of solarization. Never markets process.
1948–1950	Meets Edward Weston and is profoundly affected by his work. Begins photographing outdoors, making 'straight' images. Leads to radical transformation in artistic career.

1951–1955 Produces creatively distinctive work and begins receiving critical recognition.

1955–1959 Two photographs included in 'Family of Man' exhibition. Work featured in many other major group and one-person exhibitions. Starts teaching, lecturing, writing. Deepens what becomes lifelong study of philosophy, psychology, physics, art. Ends work at Fort Ord.

1960–1964 Receives awards in US and abroad. Begins new work – colour light abstractions.

1965–1966 Ceases colour work and resumes black-and-white photography. Showcased in film and two books.

1966–1968 Produces innovative work using long time exposures and super-imposed images. Stops all commercial photography.

1968–1970 Teaches at Chicago's Institute of Design during Aaron Siskind's sabbatical. Given major retrospective at San Francisco Museum of Art. Creates new collection of images – visually similar to haiku poetry.

1970–1973 Embarks on what is possibly his most significant stage of photographic development. Creates powerful, but unfinished, body of work. Produces two books with daughter Barbara: award-winning *Bullock* and *Wynn Bullock, Photography: A Way of Life*.

1973–1975 Releases only portfolio of black-and-white photography. Stops photographing because of illness but continues writing and philosophical pursuits. One of five inaugural artists to place archives at Center for Creative Photography. Work featured in second film.

1975 16 November, dies of cancer at home.

1976 Honoured in major retrospective at Metropolitan Museum of Art, New York. Final writing and imagery published in *The Photograph as Symbol*.

Photography is the visual medium of the modern world. As a means of recording, and as an art form in its own right, it pervades our lives and shapes our perceptions.

55 is a new series of beautifully produced, pocket-sized books that acknowledge and celebrate all styles and all aspects of photography.

Just as Penguin books found a new market for fiction in the 1930s, so, at the start of a new century, Phaidon **55**s, accessible to everyone, will reach a new, visually aware contemporary audience. Each volume of 128 pages focuses on the life's work of an individual master and contains an informative introduction and 55 key works accompanied by extended captions.

As part of an ongoing program, each **55** offers a story of modern life.

Wynn Bullock (1902–75) was one of the most widely respected photo-artists of his generation. He explored many alternative processes before adopting 'straight' photography. His evocative images are often visual metaphors, with a psychological dimension beneath the meticulous realism.

Chris Johnson is a photographic and video artist. He is also Professor of Photography at the California College of the Arts.

Barbara Bullock-Wilson has written several books on the photography of her parents, Wynn and Edna Bullock.

Phaidon Press Limited
Regent's Wharf
All Saints Street
London N1 9PA

Phaidon Press Inc.
180 Varick Street
New York NY 10014

www.phaidon.com

First published 2001
©2001 Phaidon Press Limited

ISBN 0 7148 4029 7

Designed by Julia Hasting
Printed in Hong Kong

The authors gratefully acknowledge Lynne Harrington-Bullock and Brooks Jensen for their special contribution to this book. Heartfelt thanks are also due to Kendall Clarke.